PAUL KLEE
ON
MODERN ART

by the same author

*

PEDAGOGICAL SKETCHBOOK

PAUL KLEE
ON
MODERN ART

With an introduction by HERBERT READ

Faber and Faber Ltd, 3 Queen Square, London

This English edition
Translated by Paul Findlay
first published in 1948
by Faber and Faber Limited,
3 Queen Square, London, W.C.1
First published in this edition 1966
Reprinted 1967, 1969 and 1974
Printed in Great Britain by
Unwin Brothers Limited,
The Gresham Press,
Old Woking, Surrey

ISBN 0 571 06682 8

Paul Klee's short treatise on modern art was prepared as the basis for a lecture which he delivered at the opening of an exhibition at the Museum in Jena in 1924. Some of his own work was included in this exhibition. He had already at the time been teaching for four years at the famous school of design (the Bauhaus) established under the direction of Walter Gropius at Weimar, and these notes are the product of his deep meditation upon the problems of art which the task of teaching had brought to a head. In my own opinion they constitute the most profound and illuminating statement of the aesthetic basis of the modern movement in art ever made by a practising artist. Other artists—Matisse, Picasso, Moore—have given brilliant explanations of their aims, subtle revelations of their methods and meaning. But Klee is unique in the logical consistency of his exposition. He was of a metaphysical cast of mind and widely read in philosophy and science, and proficient in still another art than his own—in music. All this gave him a wide range of reference and illustration.

Nevertheless, the reader must be prepared for difficulties. These are partly due to the cryptic, aphoristic nature of the writing; partly to the structure of the German language, which is more abstract or conceptual than is English, and therefore cannot always be exactly translated; but chiefly to the inherent difficulty of the subject. An art like painting is itself a language—a language of form and colour in which complex intuitions are expressed. The necessity for the plastic symbols of the art of painting is to some extent dictated by the inadequacy of our linguistic

means of communication. To explain art, therefore, is often an effort to give words to nameless processes, to actions otherwise confined to instinctive gestures.

To explain art—that, for Klee, meant an exercise in self-analysis. He therefore tells us what happens inside the mind of the artist in the act of composition—for what purposes he uses his materials, for what particular effects gives to them particular definitions and dimensions. He distinguishes clearly between the different degrees or orders of reality and defends the right of the artist to create his own order of reality. But this transcendental world, he is careful to point out, can only be created if the artist obeys certain rules, implicit in the natural order. The artist must penetrate to the sources of the life-force—'the power-house of all time and space'—and only then will he have the requisite energy and freedom to create, with the proper technical means, a vital work of art. But 'nothing can be rushed'. Klee, with a clarity and humility not characteristic of many of his contemporaries, realized that the individual effort is not sufficient. The final source of power in the artist is given by society, and that is precisely what is lacking in the modern artist—'Uns trägt kein Volk'. We have no sense of community, of a people for whom and with whom we work. That is the tragedy of the modern artist, and only those who are blind to their own social disunity and spiritual separateness blame the modern artist for his obscurity.

Herbert Read

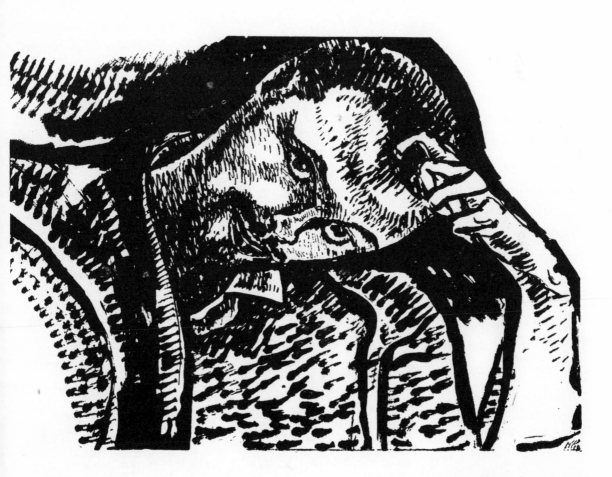

SELF-PORTRAIT 1911

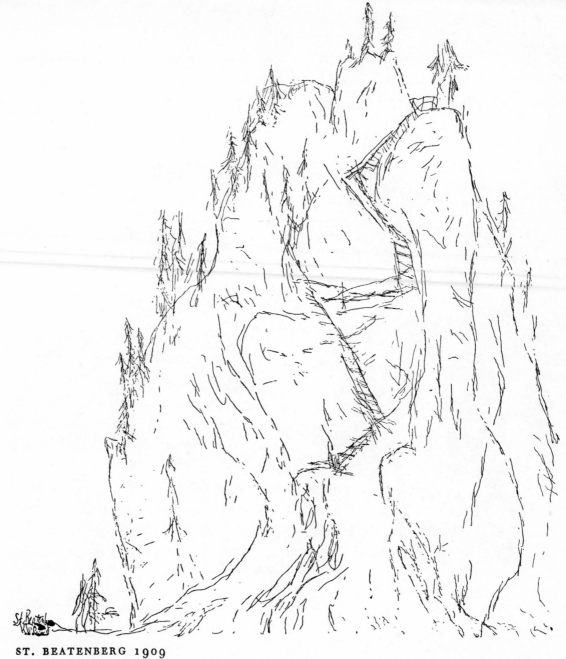

ST. BEATENBERG 1909

Speaking here in the presence of my work, which should really express itself in its own language, I feel a little anxious as to whether I am justified in doing so and whether I shall be able to find the right approach.

For, while as a painter I feel that I have in my possession the means of moving others in the direction in which I myself am driven, I doubt whether I can give the same sure lead by the use of words alone.

But I comfort myself with the thought that my words do not address themselves to you in isolation, but will complement and bring into focus the impressions, perhaps still a little hazy, which you have already received from my pictures.

If I should, in some measure, succeed in giving this lead, I should be content and should feel that I had found the justification which I had required.

Further, in order to avoid the reproach 'Don't talk, painter, paint', I shall confine myself largely to throwing some light on those elements of the creative process which, during the growth of a work of art, take place in the subconscious. To my mind, the real justification for the use of words by a painter would be to shift the emphasis by stimulating a new angle of approach; to relieve the formal element of some of the conscious emphasis which is given and place more stress on content.

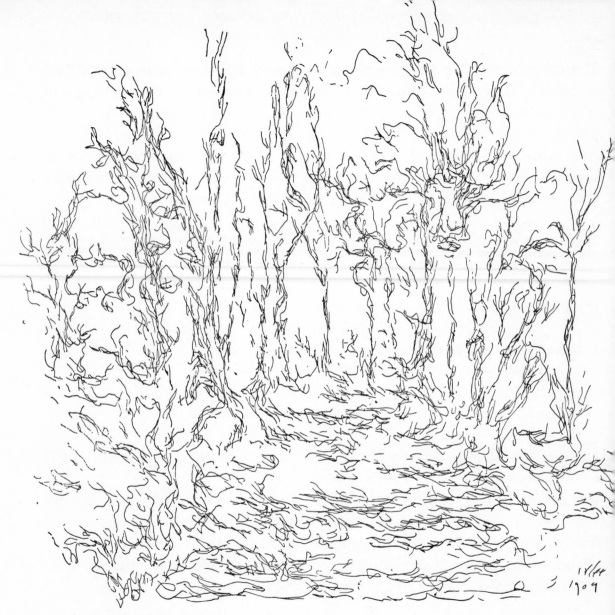

FORSAKEN GARDEN 1909

This is the kind of readjustment which I should find pleasure in making and which might easily tempt me to embark on a dialectical analysis.

But this would mean that I should be following too closely my own inclinations and forgetting the fact that most of you are much more familiar with content than with form. I shall, therefore, not be able to avoid saying something about form.

I shall try to give you a glimpse of the painter's workshop, and I think we shall eventually arrive at some mutual understanding.

For there is bound to be some common ground between layman and artist where a mutual approach is possible and whence the artist no longer appears as a being totally apart.

But, as a being, who like you, has been brought, unasked, into this world of variety, and where, like you, he must find his way for better or for worse.

A being who differs from you only in that he is able to master life by the use of his own specific gifts; a being perhaps happier, than the man who has no means of creative expression and no chance of release through the creation of form.

This modest advantage should be readily granted the artist. He has difficulties enough in other respects.

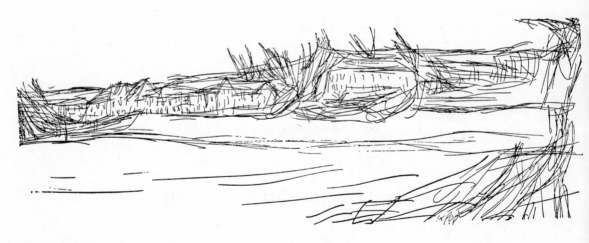

NEAR BERN 1910

May I use a simile, the simile of the tree? The artist has studied this world of variety and has, we may suppose, unobtrusively found his way in it. His sense of direction has brought order into the passing stream of image and experience. This sense of direction in nature and life, this branching and spreading array, I shall compare with the root of the tree.

From the root the sap flows to the artist, flows through him, flows to his eye.

Thus he stands as the trunk of the tree.

Battered and stirred by the strength of the flow, he moulds his vision into his work.

As, in full view of the world, the crown of the tree unfolds and spreads in time and in space, so with his work.

Nobody would affirm that the tree grows its crown in the image of its root. Between above and below can be no mirrored reflection. It is obvious that different functions expanding in different elements must produce vital divergences.

But it is just the artist who at times is denied those departures from nature which his art demands. He has even been charged with incompetence and deliberate distortion.

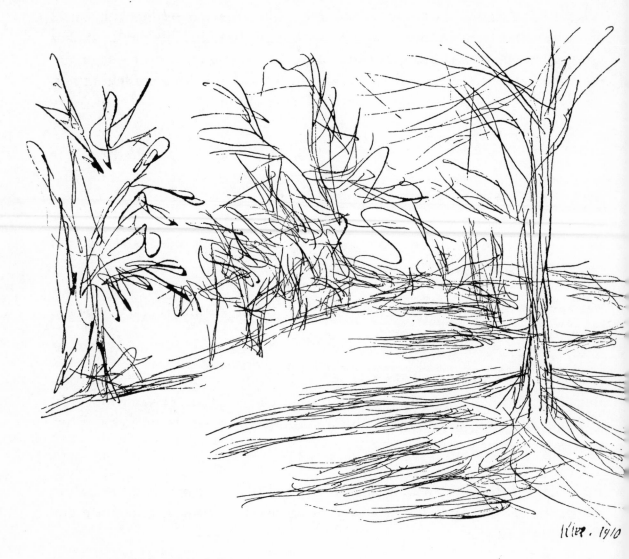

HIGH-ROAD TO SCHWABINGEN 1910

And yet, standing at his appointed place, the trunk of the tree, he does nothing other than gather and pass on what comes to him from the depths. He neither serves nor rules—he transmits.

His position is humble. And the beauty at the crown is not his own. He is merely a channel.

Before starting to discuss the two realms which I have compared with the crown and the root, I must make a few further reservations.

It is not easy to arrive at a conception of a whole which is constructed from parts belonging to different dimensions. And not only nature, but also art, her transformed image, is such a whole.

It is difficult enough, oneself, to survey this whole, whether nature or art, but still more difficult to help another to such a comprehensive view.

This is due to the consecutive nature of the only methods available to us for conveying a clear three-dimensional concept of an image in space, and results from deficiencies of a temporal nature in the spoken word.

For, with such a medium of expression, we lack the means of discussing in its constituent parts, an image which possesses simultaneously a number of dimensions.

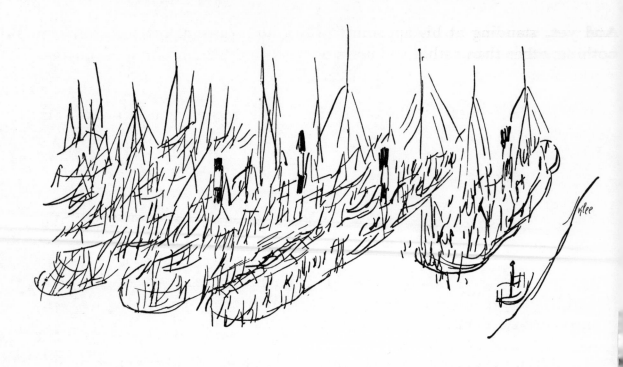

STEAMERS IN PORT 1911

But, in spite of all these difficulties, we must deal with the constituent parts in great detail.

However, with each part, irrespective of the amount of study which it may itself require, we must not lose sight of the fact that it is only a part of the whole. Otherwise our courage may fail us when we find ourselves faced with a new part leading in a completely different direction, into new dimensions, perhaps into a remoteness where the recollection of previously explored dimensions may easily fade.

To each dimension, as, with the flight of time, it disappears from view, we should say: now you are becoming the Past. But possibly later at a critical—perhaps fortunate—moment we may meet again on a new dimension, and once again you may become the Present.

And, if, as the number of dimensions grows we find increasing difficulty in visualizing all the different parts of the structure at the same time, we must exercise great patience.

What the so-called spatial arts have long succeeded in expressing, what even the time-bound art of music has gloriously achieved in the harmonies of polyphony, this phenomenon of many simultaneous dimensions which helps drama to its climax, does not, unfortunately, occur in the world of verbal didactic expression.

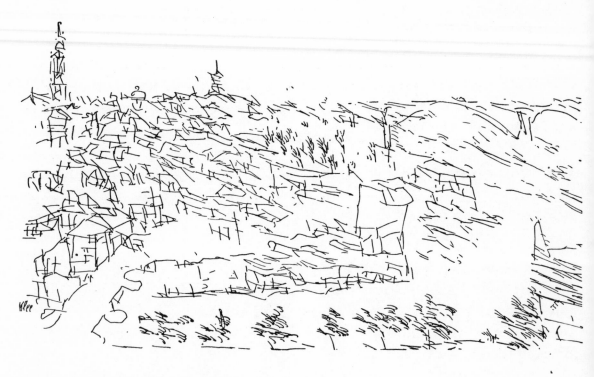

BERN: ORIGINAL WAY INTO THE CITY II 1911

Contact with the dimensions must, of necessity, take place externally to this form of expression; and subsequently.

And yet, perhaps I shall be able to make myself so completely understood that, as a result, you will be in a better position with any given picture, to experience easily and quickly the phenomenon of simultaneous contact with these many dimensions.

As a humble mediator—not to be identified with the crown of the tree—I may well succeed in imparting to you a power of rich brilliant vision.

And now to the point—the dimensions of the picture.

I have already spoken of the relationship between the root and the crown, between nature and art, and have explained it by a comparison with the difference between the two elements of earth and air, and with the correspondingly differing functions of below and above.

The creation of a work of art—the growth of the crown of the tree—must of necessity, as a result of entering into the specific dimensions of pictorial art, be accompanied by distortion of the natural form. For, therein is nature reborn.

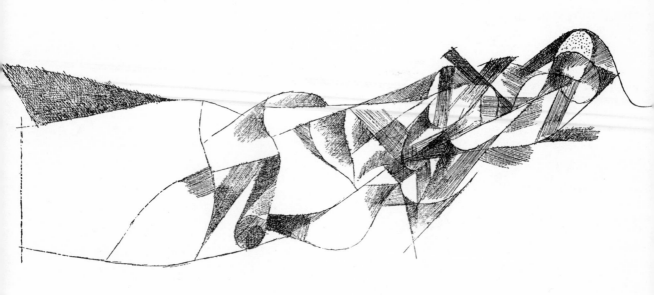

SLEEP 1914

What, then, are these specific dimensions?

First, there are the more or less limited, formal factors, such as line, tone value and colour.

Of these, line is the most limited, being solely a matter of simple Measure. Its properties are length (long or short), angles (obtuse or acute), length of radius and focal distance. All are quantities subject to measurement.

Measure is the characteristic of this element. Where the possibility of measurement is in doubt, line cannot have been handled with absolute purity.

Of a quite different nature is tone value, or, as it is also called, chiaroscuro— the many degrees of shading between black and white. This second element can be characterized by Weight. One stage may be more or less rich in white energy, another more or less weighted towards the black. The various stages can be weighed against one another. Further, the blacks can be related to a white norm (on a white background) and the whites to a black norm (on a blackboard). Or both together can be referred to a medium grey norm.

Thirdly, colour, which clearly has quite different characteristics. For it can be neither weighed nor measured. Neither with scales nor with ruler can any difference be detected between two surfaces, one a pure yellow and the other a pure red, of similar area and similar brilliance. And yet, an essential difference remains, which we, in words, label yellow and red.

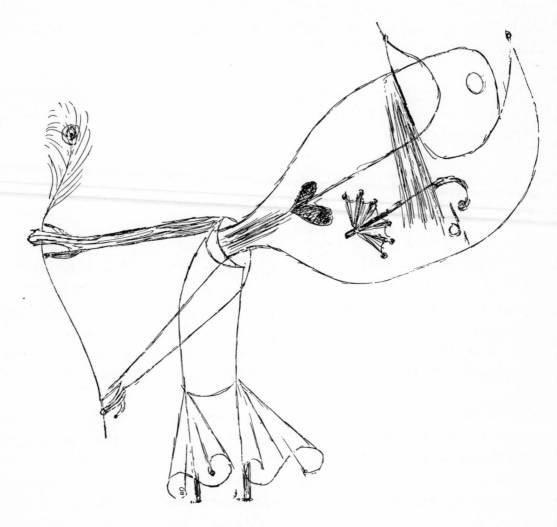

DRAWING FOR THE DANCE OF A GRIEVING CHILD 1921

In the same way, salt and sugar can be compared, in their saltiness and sweetness.

Hence, colour may be defined as Quality.

We now have three formal means at our disposal—Measure, Weight and Quality, which in spite of fundamental differences, have a definite inter-relationship.

The form of this relationship will be shown by the following short analysis.

Colour is primarily Quality. Secondly, it is also Weight, for it has not only colour value but also brilliance. Thirdly, it is Measure, for besides Quality and Weight, it has its limits, its area and its extent, all of which may be measured.

Tone value is primarily Weight, but in its extent and its boundaries, it is also Measure.

Line, however, is solely Measure.

Thus, we have found three quantities which all intersect in the region of pure colour, two only in the region of pure contrast, and only one extends to the region of pure line.

These three quantities impart character, each according to its individual

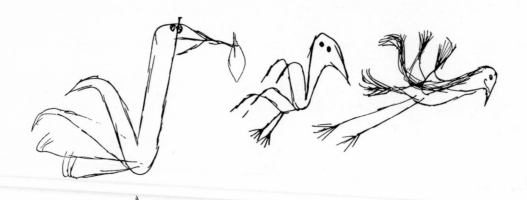

THREE BIRDS IN FLIGHT 1921

contribution—three interlocked compartments. The largest compartment contains three quantities, the medium two, and the smallest only one.

(Seen from this angle the saying of Liebermann may perhaps be best understood 'The art of drawing is the art of omission'.)

This shows a remarkable intermixture of our quantities and it is only logical that the same high order should be shown in the clarity with which they are used. It is possible to produce quite enough combinations as it is.

Vagueness in one's work is therefore only permissible when there is a real inner need. A need which could explain the use of coloured or very pale lines, or the application of further vagueness such as the shades of grey ranging from yellow to blue.

The symbol of pure line is the linear scale with its wide variations of length.

The symbol of pure contrast is the weight scale with its different degrees between white and black.

What symbol is now suitable for pure colour? In what unit can its properties best be expressed?

In the completed colour circle, which is the form best suited for expressing the data necessary to define the relationship between the colours.

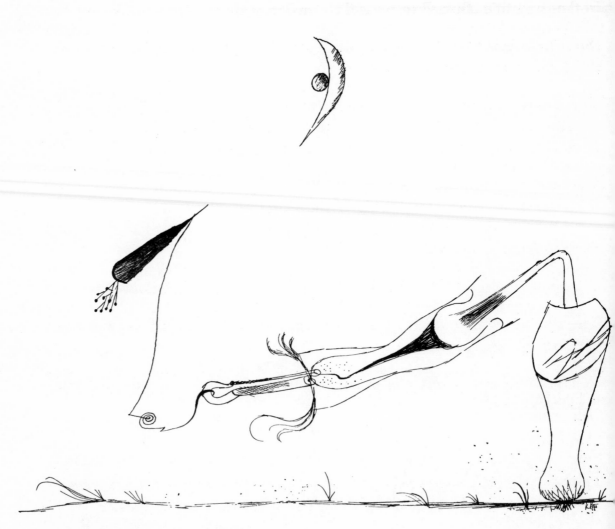

SILVER MOON-MOULD BLOSSOM 1921

Its clear centre, the divisibility of its circumference into six arcs, the picture of the three diameters drawn through these six intersections; in this way the outstanding points are shown in their place against the general backcloth of colour-relationships.

These relationships are firstly diametrical and, just as there are three dia-meters, so are there three diametrical relations worthy of mention, namely Red Green Yellow Purple and Blue Orange (i.e. the principal complementary colour-pairs).

Along the circumference the main or primary colours alternate with the most important mixed or secondary colours in such a manner that the mixed colours (three in number) lie between their primary components, i.e. green between yellow and blue, purple between red and blue, and orange between yellow and red.

The complementary colour pairs connected by the diameters mutually des-troy each other since their mixture along the diameter results in grey. That this is true for all three is shown by the fact that all three diameters possess a common point of intersection and of bisection, the grey centre of the colour circle.

Further, a triangle can be drawn through the points of the three primary colours, yellow, red and blue. The corners of this triangle are the primary colours themselves and the sides between each represent the mixture of the

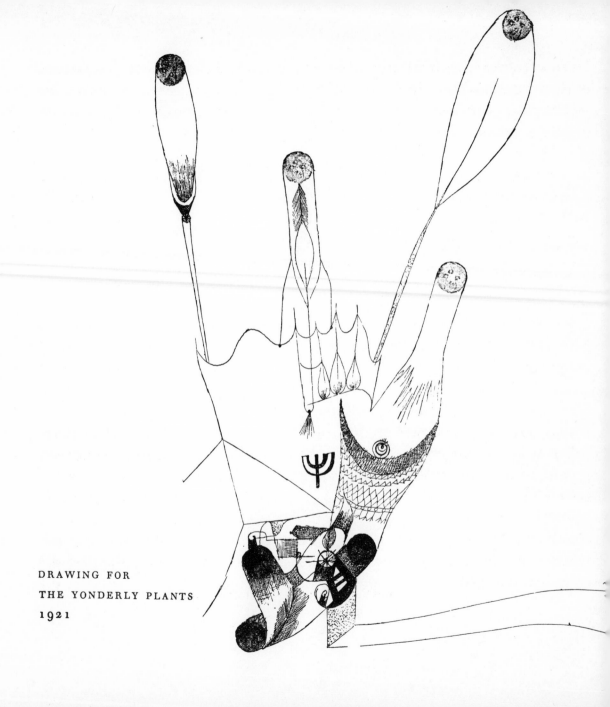

DRAWING FOR
THE YONDERLY PLANTS
1921

two primary colours lying at their extremes. Thus the green side lies opposite the red corner, the purple side opposite the yellow corner, and the orange side opposite the blue corner. There are now three primary and three main secondary colours or six main adjacent colours, or three colour pairs.

Leaving this subject of formal elements I now come to the first construction using the three categories of elements which have just been enumerated.

This is the climax of our conscious creative effort.
This is the essence of our craft.
This is critical.

From this point given mastery of the medium, the structure can be assured foundations of such strength, that it is able to reach out into dimensions far removed from conscious endeavour.

This phase of formation has the same critical importance in the negative sense. It is the point where one can miss the greatest and most important aspects of content and thus fail, although possibly possessing the most ex-quisite talent. For one may simply lose one's bearings on the formal plane. Speaking from my own experience, it depends on the mood of the artist at the time which of the many elements are brought out of their general order, out of their appointed array, to be raised together to a new order and form an image which is normally called the subject.

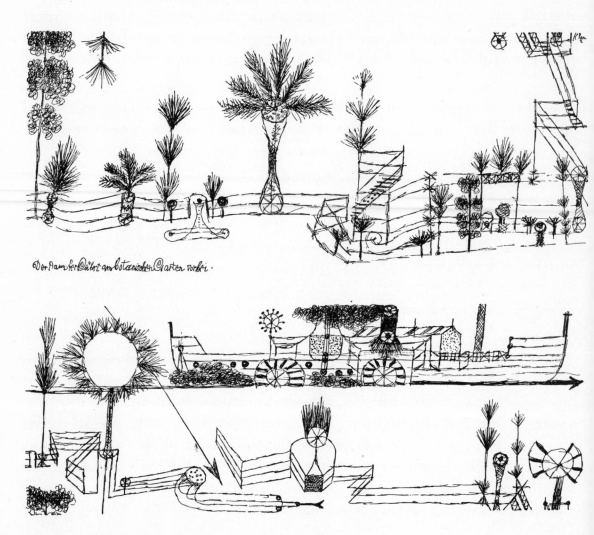

Der Dampfer fährt am botanischen Garten vorbei.

THE STEAMER PASSES THE BOTANICAL GARDENS 1921

This choice of formal elements and the form of their mutual relationship is, within narrow limits, analogous to the idea of motif and theme in musical thought.

With the gradual growth of such an image before the eyes an association of ideas gradually insinuates itself which may tempt one to a material interpretation. For any image of complex structure can, with some effort of imagination, be compared with familiar pictures from nature.

These associative properties of the structure, once exposed and labelled, no longer correspond wholly to the direct will of the artist (at least not to his most intensive will) and just these associative properties have been the source of passionate misunderstandings between artist and layman.

While the artist is still exerting all his efforts to group the formal elements purely and logically so that each in its place is right and none clashes with the other, a layman, watching from behind, pronounces the devastating words 'But that isn't a bit like uncle'. The artist, if his nerve is disciplined, thinks to himself, 'To hell with uncle! I must get on with my building. . . . This new brick is a little too heavy and to my mind puts too much weight on the left; I must add a good-sized counterweight on the right to restore the equilibrium.'

And he adds this side and that until finally the scales show a balance.

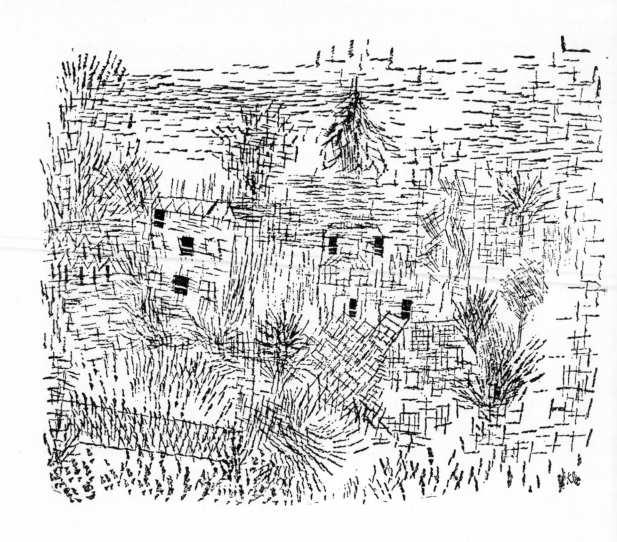

FOREST SETTLEMENT 1925

And he is relieved if, in the end, the shaking which he has perforce had to give his original pure structure of good elements, has only gone so far as to provide that opposition which exists as contrast in a living picture.

But sooner or later, the association of ideas may of itself occur to him, without the intervention of a layman. Nothing need then prevent him from accepting it, provided that it introduces itself under its proper title.

Acceptance of this material association may suggest additions which, once the subject is formulated, clearly stand in essential relationship to it. If the artist is fortunate, these natural forms may fit into a slight gap in the formal composition, as though they had always belonged there.

The argument is therefore concerned less with the question of the existence of an object, than with its appearance at any given moment—with its nature.

I only hope that the layman, who in a picture, always looks for his favourite subject, will, as far as I am concerned, gradually die out and remain to me nothing but a ghost which cannot help its failings. For a man only knows his own objective passions. And admittedly it gives him great pleasure when, by chance, a familiar face of its own accord emerges from a picture.

The objects in pictures look out at us serene or severe, tense or relaxed, comforting or forbidding, suffering or smiling.

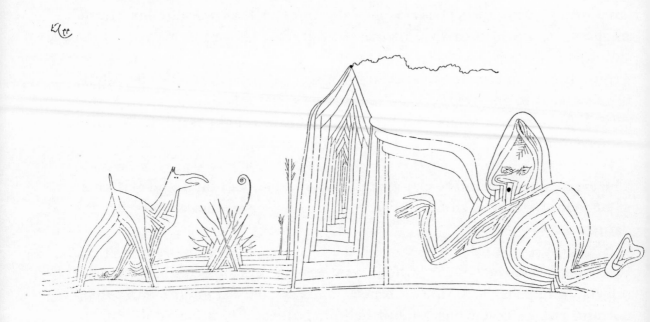

DEMONS AT THE ENTRANCE 1926

They show us all the contrasts in the psychic-physiognomical field, contrasts which may range from tragedy to comedy.

But it is far from ending there.
The figures, as I have often called these objective images, also have their own distinctive aspects, which result from the way in which the selected groups of elements have been put in motion.

If a calm and rigid aspect has been achieved, then the construction has aimed at giving either an array along wide horizontals without any elevation, or, with high elevation, prominence to visible and extended verticals.

This aspect can, while preserving its calm, lose some of its rigidity. The whole action can be transferred to an intermediate state such as water or atmosphere, where no predominant verticals exist (as in floating or hovering).

I say intermediate state as distinct from the first wholly earthbound position.

At the next stage a new aspect appears. Its character, which is one of extreme turbulence, has the effect of giving it life.

Why not?

I have admitted that, in a picture, an objective concept can be justified and have thus acquired a new dimension.

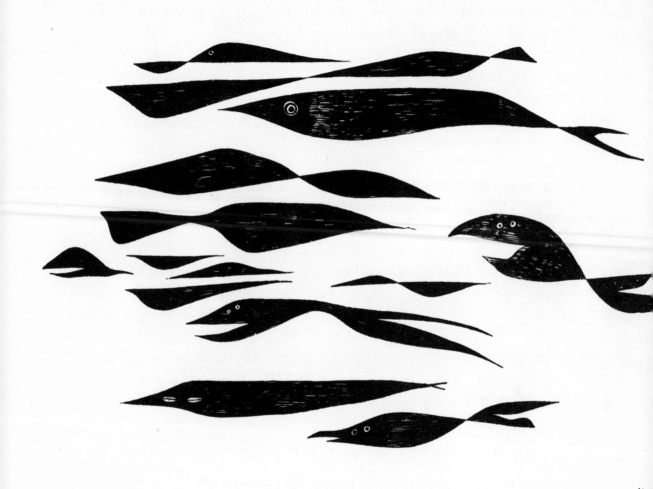

MIGRATING FISH 1926

I have named the elements of form singly and in their particular context.

I have tried to explain their emergence from this context.

I have tried to explain their appearance as groups, and their combination, limited at first, but later somewhat more extensive, into images.

Into images which, in the abstract, may be called constructions, but which, seen concretely, may be named each after the association which they have prompted, such as star, vase, plant, animal, head or man.

This, firstly, identified the dimensions of the elemental ingredients of the picture with line, tone value and colour. And then the first constructive combination of these ingredients gave us the dimension of figure or, if you prefer it, the dimension of object.

These dimensions are now joined by a further dimension which determines the question of content.

Certain proportions of line, the combination of certain tones from the scale of tone values, certain harmonies of colour carry with them at the time quite distinctive and outstanding modes of expression.

BOTANICAL GARDENS
SECTION OF
RAY-LEAVED PLANTS 1926

The linear proportions can, for example, refer to angles: movements which are angular and zigzag—as opposed to smooth and horizontal—strike resonances of expression which are similarly contrasting.

In the same way a conception of contrast can be given by two forms of linear construction, the one consisting of a firmly jointed structure and the other of lines loosely scattered.

Contrasting modes of expression in the region of tone value are given by:

The wide use of all tones from black to white, implying full-bodied strength.

Or the limited use of the upper light half or the lower dark half of the scale.

Or medium shades round the grey which imply weakness through too much or too little light.

Or timid shadows from the middle. These, again, show great contrasts in meaning.

And what tremendous possibilities for the variation of meaning are offered by the combination of colours.

Colour as tone value: e.g. red in red, i.e. the entire range from a deficiency to an excess of red, either widely extended, or limited in range. Then the same in yellow (something quite different). The same in blue—what contrasts!

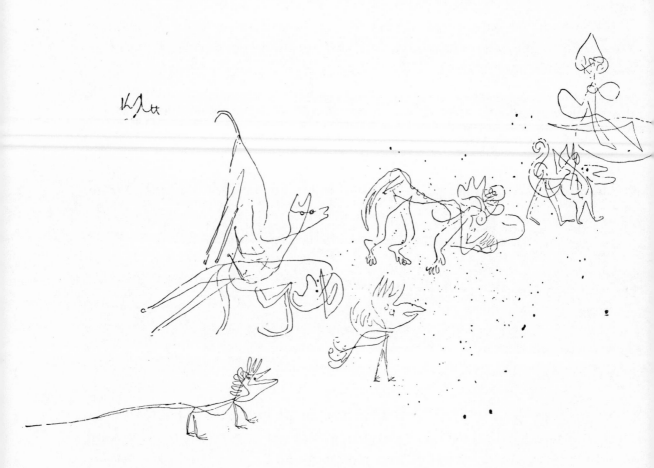

ANIMALS ON TREK 1928

Or colours diametrically opposed—i.e. changes from red to green, from yellow to purple, from blue to orange.

Tremendous fragments of meaning.

Or changes of colour in the direction of chords,[1] not touching the grey centre, but meeting in a region of warmer or cooler grey.

What subtleties of shading compared with the former contrasts.

Or: colour changes in the direction of arcs of the circle, from yellow through orange to red or from red through violet to blue, or far flung over the whole circumference.

What tremendous variations from the smallest shading to the glowing symphony of colour. What perspectives in the dimension of meaning!

Or finally, journeys through the whole field of colour, including the grey centre, and even touching the scale from black to white.

Only on a new dimension can one go beyond these last possibilities. We could now consider what is the proper place for the assorted colours, for each assortment clearly possesses its possibilities of combination.

[1]The word used by the author was 'segment'. This would appear to be a geometrical slip which has been corrected in the translation.—Translator's note.

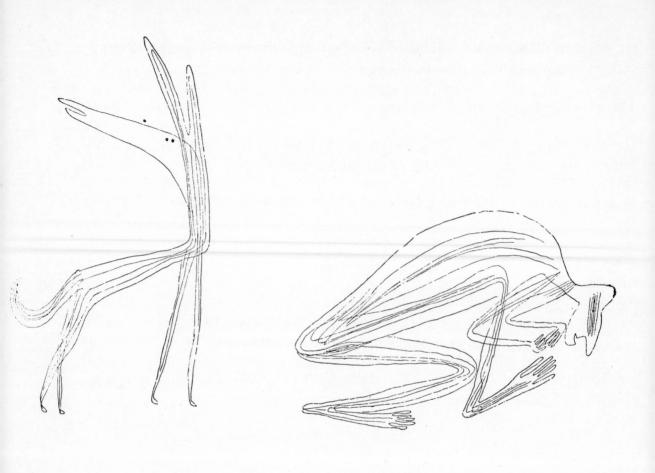

WHOSE FAULT IS IT? 1928

And each formation, each combination will have its own particular constructive expression, each figure its face—its features.

Such forceful means of expression points quite clearly to the dimension of style. Here Romanticism arose in its crassly pathetic phase.

This form of expression tries convulsively to fly from the earth and eventually rises above it to reality. Its own power forces it up, triumphing over gravity.

If, finally, I may be allowed to pursue these forces, so hostile to earth, until they embrace the life force itself, I will emerge from the oppressively pathetic style to that Romanticism which is one with the universe.

Thus, the statics and dynamics of the mechanism of creative art coincide beautifully with the contrast between Classicism and Romanticism.

Our picture has, as has been described, progressed gradually through dimensions so numerous and of such importance, that it would be unjust to refer to it any longer as a 'Construction'. From now on we will give it the resounding title of 'Composition'.

On the subject of the dimensions, however, let us be content with this rich perspective.

I would like now to examine the dimensions of the object in a new light and

Klee

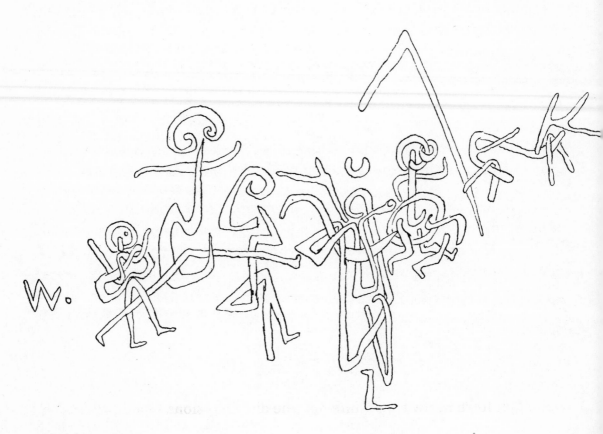

GROUP W 1930

so try to show how it is that the artist frequently arrives at what appears to be such an arbitrary 'deformation' of natural forms.

First, he does not attach such intense importance to natural form as do so many realist critics, because, for him, these final forms are not the real stuff of the process of natural creation. For he places more value on the powers which do the forming than on the final forms themselves.

He is, perhaps unintentionally, a philosopher, and if he does not, with the optimists, hold this world to be the best of all possible worlds, nor to be so bad that it is unfit to serve as a model, yet he says:

'In its present shape it is not the only possible world.'

Thus he surveys with penetrating eye the finished forms which nature places before him.

The deeper he looks, the more readily he can extend his view from the present to the past, the more deeply he is impressed by the one essential image of creation itself, as Genesis, rather than by the image of nature, the finished product.

Then he permits himself the thought that the process of creation can today hardly be complete and he sees the act of world creation stretching from the past to the future. Genesis eternal!

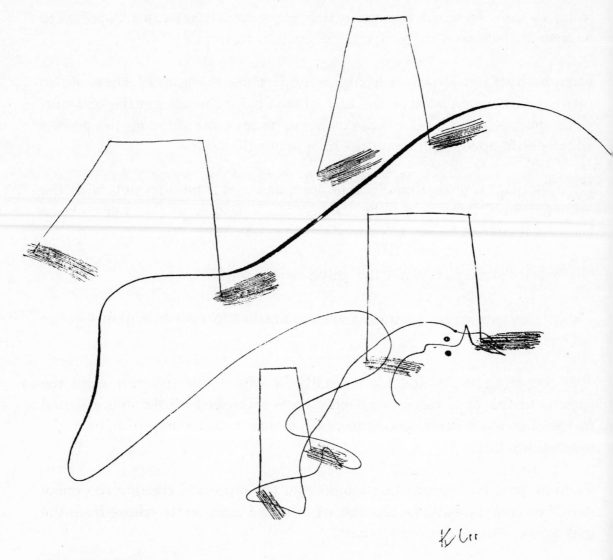

DREAMLIKE 1930

He goes still further!

He says to himself, thinking of life around him: this world at one time looked different and, in the future, will look different again.

Then, flying off to the infinite, he thinks: it is very probable that, on other stars, creation has produced a completely different result.

Such mobility of thought on the process of natural creation is good training for creative work.

It has the power to move the artist fundamentally, and since he is himself mobile, he may be relied upon to maintain freedom of development of his own creative methods.

This being so, the artist must be forgiven if he regards the present state of outward appearances in his own particular world as accidentally fixed in time and space. And as altogether inadequate compared with his penetrating vision and intense depth of feeling.

And is it not true that even the small step of a glimpse through the microscope reveals to us images which we should deem fantastic and over-imaginative if we were to see them somewhere accidentally, and lacked the sense to understand them?

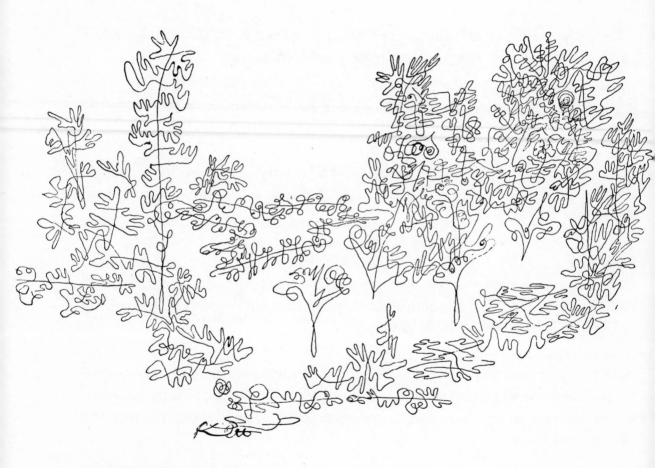

TREE-FELLING 1930

Your realist, however, coming across such an illustration in a sensational magazine, would exclaim in great indignation: 'Is that supposed to be nature? I call it bad drawing.'

Does then the artist concern himself with microscopy? History? Palaeontology?

Only for purposes of comparison, only in the exercise of his mobility of mind. And not to provide a scientific check on the truth of nature.

Only in the sense of freedom.
In the sense of a freedom, which does not lead to fixed phases of development, representing exactly what nature once was, or will be, or could be on another star (as perhaps may one day be proved).

But in the sense of a freedom which merely demands its rights, the right to develop, as great Nature herself develops.

From type to prototype.

Presumptuous is the artist who does not follow his road through to the end. But chosen are those artists who penetrate to the region of that secret place where primeval power nurtures all evolution.

There, where the power-house of all time and space—call it brain or heart of creation—activates every function; who is the artist who would not dwell there?

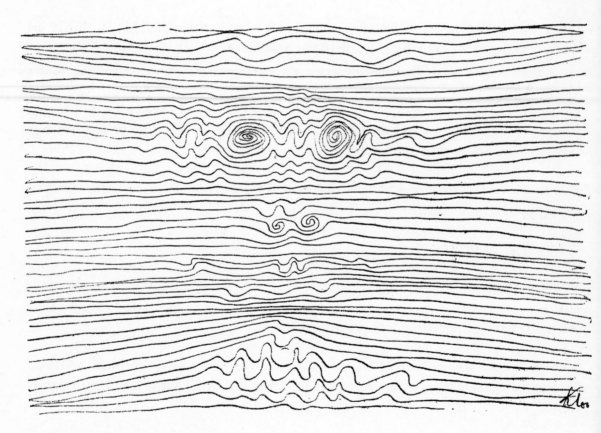

PLAY ON THE WATER 1935

In the womb of nature, at the source of creation, where the secret key to all lies guarded.

But not all can enter. Each should follow where the pulse of his own heart leads.

So, in their time, the Impressionists—our opposites of yesterday—had every right to dwell within the matted undergrowth of every-day vision.

But our pounding heart drives us down, deep down to the source of all.

What springs from this source, whatever it may be called, dream, idea or phantasy—must be taken seriously only if it unites with the proper creative means to form a work of art.

Then those curiosities become realities—realities of art which help to lift life out of its mediocrity.

For not only do they, to some extent, add more spirit to the seen, but they also make secret visions visible.

I said 'with the proper creative means'. For at this stage is decided whether pictures or something different will be born. At this stage, also, is decided the kind of the pictures.

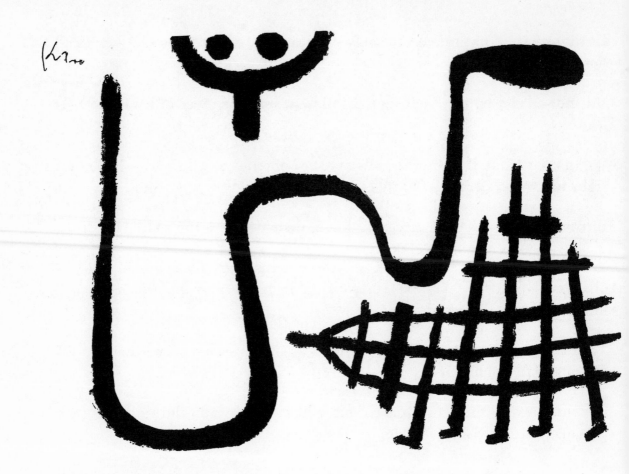

THE SNAKE-GODDESS AND HER ENEMY 1940

These unsettled times have brought chaos and confusion (or so it seems, if we are not too near to judge).

But among artists, even among the youngest of them, one urge seems to be gradually gaining ground:
The urge to the culture of these creative means, to their pure cultivation, to their pure use.

The legend of the childishness of my drawing must have originated from those linear compositions of mine in which I tried to combine a concrete image, say that of a man, with the pure representation of the linear element.

Had I wished to present the man 'as he is', then I should have had to use such a bewildering confusion of line that pure elementary representation would have been out of the question. The result would have been vagueness beyond recognition.

And anyway, I do not wish to represent the man as he is, but only as he might be.

And thus I could arrive at a happy association between my vision of life (Weltanschauung) and pure artistic craftsmanship.

And so it is over the whole field of use of the formal means: in all things, even in colours, must all trace of vagueness be avoided.

This then is what is called the untrue colouring in modern art.

As you can see from this example of 'childishness' I concern myself with work on the partial processes of art. I am also a draughtsman.

I have tried pure drawing, I have tried painting in pure tone values. In colour, I have tried all partial methods to which I have been led by my sense of direction in the colour circle. As a result, I have worked out methods of painting in coloured tone values, in complementary colours, in multicolours and methods of total colour painting.

Always combined with the more subconscious dimensions of the picture.

Then I tried all possible syntheses of two methods. Combining and again combining, but, of course, always preserving the culture of the pure element.

Sometimes I dream of a work of really great breadth, ranging through the whole region of element, object, meaning and style.

This, I fear, will remain a dream, but it is a good thing even now to bear the possibility occasionally in mind.

Nothing can be rushed. It must grow, it should grow of itself, and if the time ever comes for that work—then so much the better!

We must go on seeking it!
We have found parts, but not the whole!
We still lack the ultimate power, for:
the people are not with us.

But we seek a people. We began over there in the Bauhaus. We began there
with a community to which each one of us gave what he had.
More we cannot do.